Prince Edward Island Folk Songbook

Prince Edward Island Folk Songbook

By Wendy Jones and Teresa Doyle

Edited by Wendy Jones

Published by Wendy Jones
2014

Copyright © 2014 by Wendy Jones and Teresa Doyle

All rights reserved. This book or any portion thereof may not be reproduced or used in any manner whatsoever without the express written permission of the publisher except for the use of brief quotations in a book review or scholarly journal.

First Printing: 2014

ISBN 978-1-312-75280-1

Wendy Jones
1828 Trans Canada Highway
Belle River, PE C0A 1B0

www.peifolksongs@gmail.com

Dedication

Dedicated to the writers and singers who have poured their passion, pain, and joy into song making and by so doing preserved and shared our stories through the ages.

Table of Contents

Acknowledgements .. xi

Foreword ... xiiii

Preface .. xvii

Chapter One, Songs of Acadia .. 1
Acadian Moon
I Am an Acadian
Evangeline
Je m'apelle Évangéline
Josephine, Acadian Queen
Le Talon de Marguerite
Lune de mon Acadie
Mémé Josephine
Si J'avais Les Beaux Souliers

Chapter Two, Songs of Love and Romance ... 13
Betty's Song
Ca' the Ewes
Dance to Your Daddy
Gartan Mother's Lullaby
Going to the Country
I Dyed My Petticoat Red
Iron and Steam
Lantern Burn
MacAllar Road
Mairi's Wedding
Molly and Johnny
Queen of the Furrows
Sarah
Sparrows
Tell Me Luella
Tell My Ma
That Old Song
The Honour Song
The Red Haired Girl
The Worm Forgives the Plow
Waltzing With You

Chapter Three, Songs of the Sea ... **37**
A Rovin'
Gentle Land of My Home
Johnny's Gone-a-Sailing
Lots of Fish in Bonavist Harbour
Lukey's Boat
Peter's Dream
Sweet Molly Mavis
Tales of the Phantom Ship
The Sailor's Alphabet
Stormy Weather Boys
The Yankee Gale

Chapter Four, Songs of the Land ... **51**
Abegeweit
Canoe Round
Country Life
Island Working Man
Jimmy's Jig
Mud Beautiful Mud
Ode to Elstekook
Old MacDonald
Prince Edward Isle, Adieu
Red Dirt Road
The Mist Covered Mountains of Home
The Shearing
The Shoes of the Fisherman

Chapter Five, Songs of African Canadians ... **69**
Blackjack Byers
Dembo Suckles
Is Sook Willin'
Jupiter Wise
Klondike Gold
One Spanish Dollar
The Old Stock
The Sheppard Accident
What I Am

Chapter Six, Songs of Mirth and Magic .. 79
A Carrion Crow
A Leg of Mutton
Colcannon
False Knight on the Road
Girl on the Dunes
Home by Barna
Maggie Laughlin's Last Storm
Not An Islander
The Shan Vhan Voght
When I'm Gone

Acknowledgements

We would like to thank all of the songwriters who contributed their lyrics to our Prince Edward Island Folk Songbook. We have included links so you can hear their songs and purchase downloads. Please support our talented musicians.

Many thanks to PEI 2014 and the Prince Edward Island Cooperative Council for their sponsorship of the Prince Edward Island Folk Songbook.

Foreword

The first song I ever learned was a little ditty to the tune of The Irish Washer Woman. "Have you ever been to an Irishman's shanty where water is scare and whiskey is plenty? A two legged stool, a table to match, a string on the door instead of a latch." My Dad had his work cut out for him teaching a four year old that mouthful. Growing up in rural Prince Edward Island the fiddle was king. There really wasn't a strong folksong tradition. Our house attracted a lot of fiddlers. My father sang or 'jigged' fiddle tunes and the Hughes, The Chaissons and other fiddlers would drop by to trade tunes with him. Singers at local concerts mostly sang country music and some Irish pub songs.

I met Wendall Boyle when I went to university. He and a few others were actively reviving almost forgotten songs from the Celtic tradition. I fell in love with these songs and have never stopped digging for that special piece. When preparing a new record I often start with a stack of books several feet high and a pile of recordings. Many songs were written, few survived, but the ones that did are the 'top forty' over hundreds of years. Only the cream of the crop were passed down and those gems take us into the very hearts and minds of the people who have gone before us in a way that a history book could never do.

One of the songs I learned early in my career was Prince Edward Isle, Adieu. I was doing a degree in political science at the time and was struck by how issues haven't changed in Island politics since this commentary on confederation was composed in the 1800's. Allegedly written by the farmer poet Lawrence Doyle, the song speaks to the hard times: young people having to leave the island for work; problems with trade; the rich taking advantage of the poor; over-regulation; trouble with school trustees; and doctors and lawyers charging too much. This song reflects many problems still facing Islanders in 2014.

When my son was born in 1994 I decided to start recording Celtic music for children. Not the childish Barney pabulum that kids were being fed, but great songs like Sarah, songs my Dad had taught me, songs that the whole family could sing together. Not long after, I started a children's chorus, The Boys and Girls of Bedlamb. It was my goal to teach a whole generation of Island children 50 songs that they could sing at a kitchen party or around a campfire. Some of these kids have children of their own now and I often get asked for lyrics. That was where this project started.

In the last couple of decades the island has spawned some amazing songwriters. Our goal with this book was to start with the traditional songs that I've collected over four decades and also include some of these new writers that capture the spirit of the island in song.

Songs have offered a unique window into the lives of Islanders since the Charlottetown Conference. We hope this project inspires Islanders to dig into the music of the past 150 years and write more songs that document life on the island today.

Teresa Doyle, November 2014

Prince Edward Isle, Adieu
Lawrence Doyle, 1880's

Come all ye hardy sons of toil
Pray lend an ear to me
Whilst I relate the dismal state
Of this our country
I will not pause to name the cause
But keep it close in view;
For comrades grieve when they must leave
And bid this Isle adieu.

There is a band within this land
Who live in pomp and pride
To swell their stores they rob the poor
On pleasures' wings they ride.
With dishes fine their tables shine,
They live in princely style.
Those are the knaves who made us slaves,
And sold Prince Edward Isle.

Through want and care and scanty fare,
The poor man drags along
He hears a whistle loud and shrill,
The "Iron Horse" speeds on
He throws his pack upon his back,
There's nothing left to do;
He boards the train for Bangor, Maine,
Prince Edward Isle adieu.

The reason why so many fly,
And leave their Island home
Because 'tis clear, they can't stay here,
For work to do there's none.
In other climes there's better times,
There can't be worse 'tis true
So weal or woe, away they go,
Prince Edward Isle adieu.

But changes great have come of late,
And brought some curious things;
Dominion men have brought us in,
With our own railway rings;
There's maps and charts, and towns apart,
And tramps of every style;
There's doctors mute and lawyers cute,
Upon Prince Edward Isle.

There's judges too, who find a clue
To all the merchants' bills;
There's school trustees, who want no fees
For using all their skill;
There's laws for dogs, for geese, for hogs,
At this pray do not smile,
For changes great have come of late,
Upon Prince Edward Isle.

So here's success to all who press
The question of Free Trade;
Join hand-in-hand, our cause is grand;
They're plainly in the shade.
The mainland route, the world throughout,
Take courage now, stand true,
My verse is run, my song is done,
Prince Edward Isle adieu.

Preface

Through antiquity song has been used to preserve and share our cultural, spiritual and folk heritage, to celebrate the reasons behind festive occasions; and express our pain in times of sorrow. Folk songs have long commemorated heroic adventures and regaled us with tales of villains and adventurers, rogues and rakes, ghosts and fairies.

This is but a small collection of Island folk songs, the folk songs that we have loved throughout the 150 years since the Fathers of Confederation met to knit disparate territories into a strong and vibrant nation.

As the need arises we will be adding songs to our www.peifolksongbook.com webpage and if there is enough demand we will print an expanded version of the book. If you have a song you'd like to submit please email it to peifolksongs@gmail.com.

Chapter One

Songs of Acadia

Acadian Moon

© Jeanette Arsenault SOCAN 1994
Published by Connect Promotions & Productions
http://jeanettearsenault.ca/listentomymusic/acadieodyssey/

```
C         G              F         G       C    G
Her name was Evangeline she was the prettiest girl that they'd ever seen
C         G              F            Am       G
Oh how she loved to dance, the boys would line up waiting for their chance
   F                      G
To twirl her around and round, lift her high up off the ground
F                              G
Hand in hand, they'd start to swing; she'd begin to sing:
```

Chorus
```
C
Hey, ho away we go
F                    G      C    G
Play that fiddle and don't you go too slow, oh no
C                        F          G
Play me one more tune so I can dance by the light
          C      G
Of an Acadian Moon
```

Chorus

Gabriel stole her heart and promised her, no one could keep them apart
Together how they loved to dance, and fill up the night with romance
He would twirl her round and round, till her feet were off the ground
Hand in hand, they'd start to swing; she'd begin to sing

Chorus

```
Am                G          Am          F
They called it an Acadian moon 'cause it was like an old familiar tune
Am          G    F      G
Wherever she would roam, it reminded her of home
```
High up above, the moon shines down on two people in love
Together how they loved to dance and fill up the night with romance
He would twirl her round and round, till her feet were off the ground
Hand in hand, they'd start to swing, she'd begin to sing

Chorus x 2

I am an Acadian

© Jeanette Arsenault, SOCAN 2008
Published by: Connect Promotions & Productions
http://jeanettearsenault.ca/listentomymusic/acadieodyssey/

```
D                G             D
I am an Acadian, Dum deedle dum dum dee
G         D          E         A
I love music yes I do, it's a part of me
D                         G              F#
When my family gathers round, it's always such a treat
G          D              A         D
Someone starts to play a tune to a lively beat
G                         D
Dum deedle dum deedle dum deedle deedle dum
A                    D
Dum deedle dum deedle dum dum dum.... X 2
```

I am an Acadian, Dum deedle dum dum dee
I love music; yes I do with my family
Uncle Jacques will start off with a good old fiddle song
A lively little jig or reel we'll all play along
Zing, zing, zing….

I am an Acadian, Dum deedle dum dum dee
I love music yes I do, it lives inside of me
Someone starts a lively tune and before too long
I find myself a pair of spoons and I play along
Tiki tak tak….

I am an Acadian, Dum deedle dum dum dee
Music lifts my spirits high, deep inside of me
When the music starts to play, try as I will
I can't help but start to dance; my feet just won't keep still
Tapa tap tap….

Evangeline

© Michel Seunes
Published by Intermede Music
English lyrics by Jeanette Arsenault SOCAN 2012
Published by Connect Promotions & Productions

Gabriel's eyes shone like diamonds in the skies
 A7
As he held you by his side
Bm
The choir would soon sing and he would give a wedding ring
To you his lovely bride
D
Autumn had settled in, soon the harvest would begin
 A7
And the leaves would start to fall
Bm
The fiddlers were set to play and all the guests would say
G D A7 D
You were the loveliest of them all Evangéline, Evangéline

But the British & their guns took all the men & their sons
And locked them behind the church's door
By the first light of dawn, Gabriel & all the men were gone
As the ships sailed from the shore
The women and the young, their world had come undone
Cried out in vain
You tried your best to pray but there was nothing you could say
To take away your pain Evangéline, Evangéline

For 20 years and more you searched along the shore
And every place that you could think of
Gabriel's name was in the breeze and echoed through the trees
Carried on the winds of love
And even though your heart was deeply torn apart
Your spirit was not broken
What was it that kept you strong, was it simply your heart song
With the words left unspoken Evangéline, Evangéline

You were filled with a desire to soothe the burning fire
Of those who suffered more than you
You knew what lightens up the load at the end of a hard road
Is a hand you can hold onto
Then early one Sunday morning, in the distance without warning
You heard the church bells chime
And suddenly it was clear; your journey's end was near
You knew that it was time Evangéline, Evangéline

One dark and solemn day, there before you lay
An old man weak and unwell
As you looked into his eyes you saw diamonds in the skies
Could it be your Gabriel?
As you held him and cried, he breathed his last breath and he died
And you gently kissed his cheek
A final kiss goodbye, even heaven heard you sigh
For there were no words you could speak Evangéline, Evangéline

Though yesterday is gone, your memory lives on
And your people still remember
The ocean speaks your name, and the winds fan the flame
Of your everlasting ember
Your name is more than Acadie, more than just a page in history
It's what dreams are made of
It's for all those who weep with heartaches that run deep
But who still believe in love Evangéline, Evangéline
Evangéline, Evangéline

Je m'apelle Évangéline

© Jeanette Arsenault
SOCAN 1994
Published by: Connect Promotions & Productions
http://jeanettearsenault.ca/listentomymusic/acadieodyssey/

```
C                                    G
Je suis une Acadienne, j'm'appelle Évangéline
C                           G       C
Je surveille les plaines du haut de ma colline
C                                         G
J'ai vécu, j'ai surmonté des guerres anglaises et françaises
C                                              G      C
Et j'était là pour soulager les grandes misères et les p'tits malaises

        F            C
Vous m'avez chanté des belles chansons
          G     C    C7
Vous avez glorifié mon nom
        F         C
Vous m'avez appelé héroïne
  D     G
L'héroïne, Évangéline
```

Les louanges que vous me chantiez, croyez-moi qu'j'les apprécie
Mais il ne faut jamais lâcher car le travail n'est pas fini
En veillant sur les plaines, j'entends des bruits là bas
Je vois un peuple en peine qui luttent pour ses droits

C'est à vous mes chers acadiens
De leurs montrer le chemin
Car vous avez si bien appris l'importance
De la tolerance

C'est le temps de dévoiler l'esprit de votre courage
Et partager avec le monde entier la beauté de votre héritage
Je suis une Acadienne, j'm'appelle Évangéline
Je surveille les plaines du haut de ma colline

Josephine, Acadian Queen

© Jeanette Arsenault SOCAN 2006
Published by Connect Promotions & Productions
Tempo 90 Intro: C G C
http://jeanettearsenault.ca/listentomymusic/acadieodyssey/

```
C              G   F              C
We came from all points, north, south, east and west
     F         C          Dm          G
We gathered up our memories to share with all the rest
   Am          C       Em         F
Together we joined hearts to honour your name
       C                G     C
Oh Josephine, you're the reason we came
```

CHORUS
```
       F     G    C
Oh Josephine you left a rich legacy
F           C
I am who I am
            Dm        G
Because of who you were to me
              C
You gave us roots and gave us wings
         F
And all your love in between
       C     G     C
Oh Josephine, Acadian Queen
```

La, la, la
A family is as strong as the ties that bind
A legacy lives on through the ones left behind
I can only hope to do half as much as you
For my children, too

Chorus

Le talon de Marguerite

Traditional Acadian
http://teresadoyle.bandcamp.com/track/le-talon-de-marguerite

Marguerit' demande à sa mère un remèd' pour son talon
Sa mère y répondit: "Ma fille, un oignon, ça s'rait-i' bon?
Un oignon c'est trop rond!"

Chorus
Ah! ah! l'homme engagé connaissaint bien l'bobo de la fille.
Ah! ah! l'homme engagé connaissaint bien l'bobo qu'elle avait.

Marguerit' demande à sa mère un remèd' pour son talon
Sa mère y répondit: "Ma fille, un' tomat, ça s'rait-i' bon?
Un' tomat', c'est trop plate!
Pis un oignon, c'est trop rond!"

Chorus

Marguerit' demande à sa mère un remèd' pour son talon
Sa mère y répondit: "Ma fille, un' navot, ça s'rait-i' bon?
Un navot c'est trop gros!
Un' tomat', c'est trop plate!
Pis un oignon, c'est trop rond!"

Chorus

Marguerit' demande à sa mère un remèd' pour son talon
Sa mère y répondit: "Ma fille, un' barbot, ça s'rait-i' bon?
Un barbot', ça gigote!
Un navot c'est trop gros!"
Un' tomat', c'est trop plate!
Pis un oignon, c'est trop rond!"

Chorus

Marguerit' demande à sa mère un remèd' pour son talon
Sa mère y répondit: "Ma fille, un' anguill, ça s'rait-i' bon?
Un anguill, ça fortille!
Un barbot', ça gigote!"
Un navot c'est trop gros!"
Un' tomat', c'est trop plate!
Pis un oignon, c'est trop rond!"

Chorus
Marguerit' demande à sa mère un remèd' pour son talon
Sa mère y répondit: "Ma fille, un vieux garçon ça s'rait-i' bon?
Un vieux garçon, ah! Ça, ça s'rait bon!
Parc'qu'une anguill', ça fortille!
Un' barbot', ça gigote!
Un navot, c'est trop gros!
Un' tomat', c'est trop plate!
Pis un oignon, c'est trop rond!"

Chorus

In this Acadian children's song, Marguerite is offered many possible cures for her sore heel... an onion, a tomato, a turnip, and an eel. The hired hand spots the problem and a young man proves to be the instant cure she needs.

Lune de mon Acadie

© Micheline Lortie, Pierre Arsenault, Jeanette Arsenault
VIOLON Intro

Elle s'appelait Évangéline et l'on disait comme elle était belle
Oh! qu'elle aimait danser, les garçons s'émerveillaient d'elle
Ils aimaient la faire pirouetter, main dans la main, la faire tourner
Fatiguée et essoufflée elle voulait bien chanter

Refrain
Hé! Ho! Allons dansons
Joue ton violon et ne lâche pas, Oh! Non!
La soirée n'est pas finie
Je veux danser sous la lune de mon Acadie

Solo violin

Gabriel lui a promis qu'ils resteraient toujours unis
Oh! Qu'ils aimaient danser sous le ciel de leur Acadie
Doucement, et sans ennuis, ils dansaient tard dans la nuit
Le pied léger sans se lasser, elle voulait bien chanter

Refrain
Solo violin

Sous la lune de son Acadie
Oh! qu'elle aimait chanter cette petite mélodie
Partout où elle le cherchait
De sa patrie, la lune lui rappelait

La lune éclaire dans la nuit
On voit les deux amants qui dansent enlacés
Ils dansent tout à l'entour
Dans la magie d'une nuit d'amour
Il aime la faire pirouetter, main dans la main, la faire tourner
Glissant léger, sans se lasser, on l'entend chanter.

Refrain
Solo violin
Refrain X 2

Mémé Josephine

© Jeanette Arsenault SOCAN 2006
http://jeanettearsenault.ca/listentomymusic/acadieodyssey/

```
C
I remember back long ago
                         F
I used to play on your old piano
           C       Am
You'd be baking up apple pie
     F            G
The aroma would slowly drift by
```

I'd play you song after song
God bless you, you'd sing along
You loved to hear me play
Or at least that's what you would say

```
F     E7          Am
Mémé Josephine you're my hero
          F
Oh yes you are
         C              G7
You outshine the brightest star
Dm7(9) G7(13) C
Mémé Josephine
```

The piano's no longer there
And the room seems so bare
My memories have taken its place
Filling my heart's empty space

I can still see the smile in your eyes
Feel the strength of a woman so wise
All the love that I was shown
Is the legacy you had seamlessly sewn

Si j'avais les beaux souliers
Traditional Acadian
https://teresadoyle.bandcamp.com/album/if-fish-could-sing-and-sheep-could-dance

Si j'avais les souliers
Qu'ma mignonn' m'avait donnes
Si j'avais les souliers
Qu'ma mignonn' m'avait donnes
Mes souliers d'papier

Chorus
Mes souliers sont rouges
Ma mignonne, ma mignonne
Mes souliers sont rouges
Ma mignonne, mes amours

Si j'avais les beaux bas
Qu'ma mignonn' m'avait donnes! (bis)
Mes beaux bas d'peau d'chat Mes souliers d'papier

Chorus

Si j'avais les culottes…(bis)
Mes culott's de potte-en-potte
Mes beaux bas d'peau d'chat

Chorus

Si j'avais la ceinture…(bis)
Ma ceintur' de confiture
Mes culott's de potte-en-potte

Chorus

Si j'avais le chapeau…(bis)
Mon chapeau bien haut
Ma ceintur' de confiture
Mes culott's de potte-en-potte
Mes beaux bas d'peau d'chat
Mes souliers d'papier

Chorus

Chapter Two

Songs of Love and Romance

Betty's Song
© Ashley Condon January, 2012
http://www.ashleycondon.com/music/

My momma knew the roads like the back of her hand
In her old green ford she'd ride like the wind
Up and down and back again
My momma worked hard with her hands
On a boat ten miles from land
She'd work those days that most people can't

But I wanted things that the other kids had
Like a brother or a sister and a dad
I was just too young to really understand

My momma fought for everything she had
For fifteen years and thirty grand
She owned her home and all of her land
My momma never really found romance
They'd come and go like a passing glance
Here, then gone and never back again

But I wanted things that the other kids had
Like a brother or a sister and a dad
I was just too young to really understand
That my momma did the best that she can
Making me the woman that I am
And I think that I may finally, I think that I may finally…
Understand

My mother was a fisher and a beautiful spirit. As I get older I appreciate her more and more, and understand how she has shaped who I have become. Betty passed away on Nov. 6th 2002.

Ca' the Ewes

Traditional Scottish
http://teresadoyle.bandcamp.com/album/if-fish-could-sing-and-sheep-could-dance

Chorus
Ca' the yowes to the knowes
Ca' them where the heather grows
Ca' them where the burnie rowes
My bonny dearie.

We'll gae doon by Cluden side
Thru the hazels spreading wide
O'er the waves that sweetly glide
To the moon sae clearly.

Chorus

Hark the mavis evenin' song
Soundin' Cluden's woods amang
Then a-foldin' let us gang
My bonnie dearie.

Chorus

Fair and lovely as thou art
Thou hast stol'n my very heart.
I can die but canna part
My bonnie dearie

Chorus

Dance to Your Daddy
Traditional Irish
https://teresadoyle.bandcamp.com/album/dance-to-your-daddy

Dance to your daddy my little laddy
Dance to your daddy my little man
When thou art a man and come to take a wife
You shall find a lass and love her all your life
She shall be your lass and ye shall be her man
Dance to your daddy my little laddy
Dance to your daddy my little man.

Dance to your daddy my little laddy
Dance to your daddy my little man
Thou shall have a cup and thou shall have a can
Thou shall have a coddlin' when the boat comes in
Thou shall have a haddock baked in a pan
Dance to your daddy my little laddy
Dance to your daddy my little man.

Garten Mother's Lullaby
Traditional Irish
http://teresadoyle.bandcamp.com/track/garten-mothers-lullaby

Sleep my child for the red bee hums
The silent twilight falls
Aoibheall from the grey rock comes
And wraps the world in thrall
A leanbhan 'O, my child, my joy
My love my heart's desire
The crickets sing you lullaby
Beside the dying fire.

Dusk is drawn and the green man's thorn
Is wreathed in rings of fog
Siabhra sails his boat 'til morn
Upon the starry bog
A leanbhan 'O the pale half moon
Hath brimmed her cusp with dew
And weeps to hear the sad sleep tune
I sing my love to you.

Faintly sweet doth the chapel bell
Ring o'er the valley dim
Tearmann's peasant-voices swell
In fragrant evening hymn.
A leanbhan O, the low bell rings
My little lamb to rest
And angel-dreams till morning sings
Its music in your head.

Going To The Country

© Ashley Condon 2010
http://www.ashleycondon.com/2012/05/new-vid-going-to-the-country-a-k-a-the-woodpile-song/

Everything is changing
Life is rearranging
I'm going to the country
Maybe have me a baby
It's funny how I never knew
What it would look like till I met you
Now we're going to the country
To start anew

We can have a garden
A little place to put our hands in
I'll start pickling
Like my grandma did
And I'll take up baking
You can start a' making
All of those things
That you keep saying

Cuz

Everything is changing
Life is rearranging
I'm going to the country
Maybe have me a baby
It's funny how I never knew
What it would look like till I met you
Now we're going to the country
To start anew

You can have a wood pile
I'll have a clothesline
And we'll have a fire every night
Down by the riverside
And all through the evening
We'll be a' singing
Hallelujah
To our home

So baby when I'm lonely
I know that you'll hold me
And tell me a story
Of how we'll be fine
Then you can take me
Down to the sea
And we'll stand hand in hand
Silently

Cuz

Everything is changing
Life is rearranging
I'm going to the country
Maybe have me a baby
It's funny how I never knew
What it would look like till I met you
Now we're going to the country
To start anew

It's funny how I never knew
What it would look like till I met you
Now we're going to the country
To start anew

I wrote this song a few months before we moved into our new country home in PEI. It was a huge transition for both of us, and one of the most joyful experiences of my life.

I Dyed My Petticoat Red

Nova Scotia version of a traditional English song
http://teresadoyle.bandcamp.com/track/i-dyed-my-petticoat-red

I dyed my petticoat, I dyed it red,
And around the world I begged my bread,
Friends and relations think me dead,
Call the cat, the kid-a-lee-ack, the low.

Chorus
Shoal, shoal, shoal the back-er-ol,
Shoal the ramsack call and the pocatoo,
While they call the cat the kid-a-lee-ack,
The willikey willikey wum,
'Til they niddle-e-ack, niddle-e-ack night night night.

Chorus

I wish and I wish and I wish in vain,
I wish I was a young maid again,
A maid again I never shall be,
'Til cherries grow on an apple tree.

Chorus

I churned my butter with a bullikin boot,
I churned it round with a muddy old scoot,
Friends and relations think it cute,
Call the cat the kiddle-e-ack the low.

Chorus x2

Iron and Steam
© John MacAllar Music 1999
https://www.youtube.com/watch?v=Y2xzxPJ5fu0&spfreload=10

The year was 1873 when we joined confederation
They said they'd help build us a railroad if we became part of the nation
From Tignish to Elmira they laid the tracks on the ground
Like a snake it crossed the Island a lifeline from town to town
The farmers would load their potatoes and wheat
Where the road and rail would meet
The steam would rise up from her stack
As she rolled on down the track

She carried her Island people from destination to destination
Over streams and over rivers the number one mode of transportation
But by the mid 1970's trucks were fast and roads were good
This old Iron Soldier kept pace the best she could
And when the next decade came he was considered too slow
Too expensive to maintain so the railroad would have to go

One day in the 80's they tore the last section down
It made one final run from Summerside to Charlottetown
There we ended an era, a time of iron and steam.
100 years or more of service spawned by a politician's dream
Now I walk down the trail can't help but think about the rail.
I see her steam rise from her stack
I can hear her rollin' down the track
She ain't never comin' back so let her ghost roll down the track
Let her ghost roll down the track….

Lantern Burn
© Steve Sharratt SOCAN 1994

Will he see my lantern burn on this pitch-black coast tonight,
Will he know my heart beats strong, a beacon of sweet light,
Can he see my frightened eyes, can he hear my trembling cries,
And it's only when he's near will I be right.

He went to sea sometime ago and I yearn for his return,
With every storm that rocks this shore, I make the fire burn.
Can he touch me through the mist, can he taste my gentle kiss,
And it's only when he's near will I be right.

They say his ship is ran aground and every hand was lost,
These cliffs I'll walk the winter long, till my heart is numb with frost,
I swore to him we'd never part, I cannot save his drowning heart,
And it's only when he's near will I be right.

MacAllar Road
© John MacAllar Music 2003
https://www.facebook.com/jhmacallar

I can hear the fiddle through the open window
Boy can he ever play
There's dancing in the kitchen and stories on the tongue
They're talking 'bout yesterday
Times are quiet now but they
Weren't always that way
When everybody lived down on MacAllar Road

A family of 15 lived a simple life
Fished the waters, farmed the land
They would never be the wealthy kind
Life was hard you understand
And when the depression came
some left for Montreal
They said their goodbyes to MacAllar Road

In 1939 a war broke out the boys went overseas
They left behind the ones they love to fight for their country
And if you go to France
my namesake's buried there
They did their part, the boys from MacAllar Road
The Boys from MacAllar Road

There's a little graveyard by a river they call Brae.
And that's where you'll find the name you'll never see in any history book.
But they're good folk just the same
Someday I'm gonna die one request before I do
Will you bury me somewhere close to MacAllar Road
Good ole MacAllar Road

Mairi's Wedding

Traditional Scottish
http://teresadoyle.bandcamp.com/track/mairis-wedding

Chorus
Step we gaily as we go,
Heel for heel & toe for toe,
Arm in arm and on we go,
All for Mairi's wedding.

Over hill ways up & down,
Myrtle green & bracken brown,
Past the sheeling through the town,
All for the sake of Mairi.

Chorus

Plenty herring, plenty meal,
Plenty peat to fill her creal,
Plenty bonny bairns as weel,
That's the toast for Mairi.

Chorus

Cheeks as bright as rowans are,
Brighter far than any star,
Fairest of them all by far,
Is my darling Mairi.

Chorus

Molly and Johnny
Traditional Irish
http://teresadoyle.bandcamp.com/track/molly-johnny

Molly & Johnny they sat reposing
Under a bank of blooming roses
While at the sea the ship was waiting
That young couple sat repeating. Love farewell.
Darling farewell and it's all for parting. Love farewell.

Oh Johnny dear now do not leave me
For your absence it would grieve me
For if you go where the cannons rattle
I fear my love will fell in battle. Love farewell.
Darling farewell and it's all for parting. Love farewell.

Oh Molly dear, now do not mourn
For there's a relief at my returning
For when I get back from the war's alarm
I'll gently roll you in my arms. Love farewell.
Darling farewell and it's all for parting. Love farewell.

The old woman said now do not grieve me
Do not take my daughter from me
For if you do I will torment you
At my death my ghost will haunt you. Love farewell.
Darling farewell and it's all for parting. Love farewell.

The ship now she sails on the briny ocean
Seeking out for high commotion
The trumpets sound and the drums are beating
Hush me boys for there's no retreating. Love farewell.
Darling farewell and it's all for parting. Love farewell.

Queen Of The Furrows

© Eddy Quinn from the Fiddlers' Sons album - This Is My Island
https://www.facebook.com/eddy.quinn.750

Well they say I was a handful don't ya know
Long before I ever settled down
Cause I swung a wide loop and I never said no
To an offer for to paint the town
Well I had a great time and I sang my songs
Met people from east to west
But it's closer to home where my heart belongs
To the woman that I love the best

At the close of summer there's a county fair
In the village that we call Dundas
They have a great big party showing livestock there
When the farmers hold their plowing match
It was there I met her in a field of clover
Best woman that I ever have seen
She didn't mind getting dirty turning red clay over
So they made my little darlin' queen

Chorus
Now Charlottetown has the gold cup girls
And Souris has queen of the sea
There's a miss Northumberland in Murray River
But the queen of the furrows is the girl for me
Queen of the furrows is the girl for me

At the oyster festival their Miss Tyne Valley
Has a daddy that you wouldn't want to cross
You'll be very best buddy with a Tignish honey
You'll be bringing in the Irish moss
At the lobster Carny little west end Mary
Drove me crazy up in Summerside
'Round the Bay of St Peters pick a sweet blueberry
To make yourself a mighty fine bride

Chorus
Repeated Chorus

Down in Rustico they never let you go
They're even sweeter in Evangeline
Downtown Morell the women cast their spell
But the queen of the furrows is the girl for me
Queen of the furrows is the girl for me

Sarah

Traditional Newfoundland
http://teresadoyle.bandcamp.com/track/sarah

I came upon a charming girl and Sarah is her name,
Her parents want a husband with riches, wealth, and fame;
I haven't the wealth, and riches and fame have never come my way,
Till the night I went to visit my love and through the keyhole said:

Chorus
Sarah, Sarah, won't you come out tonight?
Sarah, Sarah, the moon is shining bright;
Put your hat and jacket on, tell your mother you won't be long,
And I'll be waiting for you 'round the corner.

Oh Sarah is a girl like this, a girl you seldom see,
She only loves me for myself and not for my money;
Every night at eight o'clock she puts the needle away,
And standing just outside her door I through the keyhole say:

Chorus

One night a little after eight I crept up to her door,
I whispered, "Sarah, darling," as I'd often done before;
"I'll give you Sarah" said a voice, as down I went in a flop,
That's what her mamma said as she chased me 'round the shop.

Chorus

Sparrows
© Catherine MacLellan
http://catherinemaclellan.storenvy.com/products/10917777-the-ravens-sun

All the days that you were here
Have disappeared from my mind
Now only silhouettes and shadows remain
Darling nothing is the same.

Chorus:
Where are you now in this world?
Is your voice being heard among the sparrows?
Where are you now in this lonely world?
Is your voice being heard among the birds?

All the things that you did show me my friend
Have stuck to me like grains of sand
Letters spilled, ink blurred by tears
Tucked away in darkness stand.

Tell Me Luella
© Catherine MacLellan
http://catherinemaclellan.storenvy.com/products/10917777-the-ravens-sun

Tell Me Luella
Tell me Luella, tell me where have you gone
Tell me Luella, tell me where have you gone
Are you walking that golden highway home?
Are you walking that golden highway home?

The toughest little gal to ever leave the Prairies
She traveled East to watch the rising sun
She's left us now and she ain't coming back this way
She's left us now and she ain't coming back this way

The last time that I saw her she was smiling
Looked like she had one last game to play
I waved goodbye, said I'd be back tomorrow
I waved goodbye, said I'd be back tomorrow

Tell me Luella, tell me where have you gone
Tell me Luella, tell me where have you gone
Are you walking that golden highway home?
Are you walking that golden highway home?

No one knew for certain she was leaving
But somehow each of us did know
When the flood is coming you head for higher ground
When the flood is coming you head for higher ground

Tell me Luella, tell me where have you gone
Tell me Luella, tell me where have you gone
Are you walking that golden highway home?
Are you walking that golden highway home?

Tell My Ma

Traditional Scottish
http://teresadoyle.bandcamp.com/track/tell-my-ma

Chorus
Tell my ma when I go home
The boys won't leave the girls alone
They pull my hair and they stole my comb
But that's alright 'till I go home
She is handsome. She is pretty
She's the bell of Belfast City
She's a courting one, two, three
Please won't you tell me, who is she.

Albert Mooney says he loves her
All the boys are fighting for her
They knock on the door and they ring the bell
Oh my true love are you well
Here she comes as white as snow
Rings on her fingers, bells on her toes
Old Johnny Murray he says she'll die
If she doesn't get the fellow with the rovin' eye.

Chorus

Let the wind & the rain and the hail blow high
And the snow come tumbling from the sky
She's as nice as apple pie
She'll get her own boy by and by
If she gets a lad of her own
She won't tell her ma till she comes home
Let the boys stay as they will
For it's Albert Mooney she loves still.

Chorus

That Old Song
© Joyce Marion Cobbs MacLean

That old song is many years old
Yet that old song has never been sold
That old song lies in every heart
For that old song is a work of art.

That old song it has no tune
Yet that old song can sure fill a room
That old song has only one line
But that old song can really mark time.

That old song is always a hit
To that old song we walk and we sit
That old song can turn the hair grey
But that old song is here to stay.

That old song will go on and on
As that old song each new day is born
That old song will never die
For that old song is a new baby's cry.

The Honour Song
© George Paul
Mi'kmaq call for honour and unity among the people

Gĕp mē tē tĕm ăn ĕtj
dŏn deli Inno ölteewk
Let us Honour the people we are
Nēgăm atjtöt mŏwē don ĕtj
My people let us unite.

Gĕp mē tē tĕm ăn ĕtj
dŏn wĕdăbĕksölteewk
Let us honour our ancestral lineage
Nēgăm atj tot aboken
mă döltin ĕtj
My people let us help one another

Ăbok ĕn mă döltin ĕtj dŏn gisoolk dĕl
ikâlökseewk ölă öksitkămö
(Chant only: Wey yah hey yo)
Let us help one another the way our creator
has placed us here upon Mother Earth

I traveled out west to Alberta in 1983 to visit a wise elder (Spiritual Leader) named Buffalo Child, most commonly known as Albert Lightening; Albert had been conducting ceremonies for our people here in the east coast a few years ago. This time we were going to attend ceremonies out there.

Our first ceremony was a Sundance conducted by Harold Cardinal and his family, which was being held at the Alexander Reserve, 40 miles north of Edmonton in a wooded area. This was my first experience in a ceremony of that type, but it was at this ceremony where I saw a vision.

Shortly after, we went to Kootenay Plains, somewhere near Two O'clock Creek. Albert Lightening was conducting ceremonies and there were many people from different parts of the world attending. There were people from my home area that had grown akin to Albert and his ceremonies. Around the campfire at night, the talk was about reviving our culture.

I had a feeling in my heart too fast for an understanding. To learn why my people lost so much, and the question: What did we do so wrong to have lost our songs, our ceremonies, and our dances? During my fast this feeling hit me and it weighed heavy on my heart. I couldn't help but cry. I cried until the crying turned into a chant and it was this chant that gave the message, the message of unity. My people let us work together towards that unity, be proud of who you are, believe in the power of the creator, believe in yourself.

Tahoe! George Paul

The Red Haired Girl
© Mark Haines words and music. All rights reserved SOCAN

```
A                                D        A
Well it's early in the morning and the stars are falling,
A                                    E
Over the fields where the sun's comin' up,
      A                       D        A
And into the woods where the dreams are calling,
A        E         A
Goes the little red haired girl.
A                                D        A
She's wild as the wind blowin' on the ocean,
A                                    E
Sweet as the breeze in the tops of the trees,
         A                 D        A
She's off in a whirl if she takes a notion,
A        E         A
Oh the little red haired girl.
```

Chorus

```
        D        A          D         E
And all around Avonlea, and all around the world,
             A                   D
You're never gonna find another like,
             A                 E
The lovely little red haired girl,
         D       E         A
I love the little red haired girl.
```

```
A                                   D        A
She's got a smile as bright as a summer mornin',
A                    D        E
Heart as light as a Christmas Day,
       A                        D        A
A temper that'll tune you without warnin',
A        E         A
Oh the little red haired girl.
```

Chorus

 G A
And she wonders if she's pretty,
 G A
Some day I'll tell her so,
 G A
And you wonder what she's thinking,
 G E
But you'll never ever know.

 A D A
I could take all the tea that's grown in China,
A D E
Take all the money that runs this world,
A D A
Trade it all away for a walk down the lane,
D E A
With the little red haired girl.

Chorus

The Worm Forgives the Plow
© Steve Sharratt SOCAN 1996

Quiver of the seed, dawning of the deed
Leathered are the hands worn to the bone
The frost forgives the thaw like the tree forgives the saw
Life is what the season's hone.

Chorus
And the moon clings like a tear, on the cheek of a cold night clear
Snow may bend the bough be there faith in every vow
Forever will the worm forgive the plow.

The Clyde can pull the gang, with its tine worn to the tang
On will that's somehow bred within the bone
And the earth forgives the hoe like the shake forgives the froe
Life is what the season's hone.

Chorus

Waltzing With You
© Meaghan Blanchard

One, Two Three, Two, Two Three, please take my hand,
Waltz me in circles beautiful man,
And what better way to show our love is true
One, Two Three, Two, Two Three, waltzing with you.

Once I was a flower who clung to the wall
Now I'm a dancer, Since you came along.
And what better way to show our love is true
Than One, Two Three, Two, Two Three, waltzing along.

Like Mamma and Daddy, our grandparents too,
They had it right, in their old dancing shoes,
And what better way to show how I love you
One, Two Three, Two, Two Three, waltzing with you.

Like Mamma and Daddy, our grandparents too,
See, they got it right, in those old dancing shoes,
And what better way to show how I love you
You, You
One, Two Three, Two, Two Three, waltzing with you.

Chapter Three

Songs of the Sea

A-Rovin'

An English folk song adapted by Teresa Doyle
http://teresadoyle.bandcamp.com/track/a-rovin

In Charlottetown there lived a maid
Bless you young women
In Charlottetown there lived a maid
Now mind what I do say
In Charlottetown there lived a maid
And she was mistress of her trade
I'll go no more a roving with you fair maid.

Chorus
A-roving. A-roving.
Since roving is my ruin
I'll go no more a-roving
With you fair maid.

I took this fair maid for a walk
Bless you young women
I took this fair maid for a walk
Now mind what I do say
I took this fair maid for a walk
And we had such a lovely talk
I'll go no more a roving with you fair maid.

Chorus

She swore that she'd be true to me
Bless you young women
She swore that she'd be true to me
Now mind what I do say
She swore that she'd be true to me
Spent my pay so fast and free
I'll go no more a rovin' with you fair maid.

Chorus

Scarce had I been gone to sea
Bless you young women
Scarce had I been going to sea
Now mind what I do say
Scarce had I been gone to sea
When a soldier took her on his knee
I'll go no more a rovin' with you fair maid.

Gentle Land Of My Home
©Rollie MacKinnon

Chorus
Roll gentle seas to the shores of my Island
blow gentle breeze billowed sales fly me home.
To the scent of the flowers the wild rose of summer
the green wooded hills gentle land of my home.

Come rest and I'll tell you the memory of my youth
the rivers the fields the warmth of the sand.
The farmers, the fishers, kind hearts and strong hands
let my mind ever linger in that fair gentle land.

Chorus

Soft flowing rivers the marsh and the meadows
sea birds float softly against the clear sky.
In my dreams I remember the warmth of the summer
let my heart ever linger in that fair gentle land.

Chorus

Far away I have wandered across the great oceans
nowhere have I found a place to call home.
So fair wind fill my sails and gray seas pass under
and steady my course to that fair to that fair gentle land.

Chorus

Johnny's Gone-A-Sailing

Traditional Nova Scotia
http://teresadoyle.bandcamp.com/track/johnnys-gone-a-sailing

Johnny's gone a-sailing with trouble on his mind,
For the leaving of his country, and his darling girl behind.
Dor a lee a laddle, Dor a lee my lily O.

"Before you step on board sir, your name I'd like to know,"
With a smile upon her countenance she answered, "Jack Munro."
Dor a lee a laddle, Dor a lee my lily O.

"Your waist it is quite slender and your fingers they are small,
And your cheeks they are too rosy for to face the cannon ball."
Dor a lee a laddle, Dor a lee my lily O.

"My waist it is quite slender and my features they are small,
But I never faint nor falter if ten thousand round me fall."
Dor a lee a laddle, Dor a lee my lily O.

"I am not your daughter, and her I do not know,
For I've just come from the battlefield, they call me Jack Munro."
Dor a lee a laddle, Dor a lee my lily O.

Lots of Fish in Bonavist Harbour

Traditional Newfoundland Folk Song
http://teresadoyle.bandcamp.com/track/lots-of-fish-in-bonavista-harbour

Oh there's lots of fish in Bonavist Harbour
Lots of fish right in around here
Boys and girls are fishing together
Forty-five from Carbonear.

Chorus
Catch a hold this one, catch a hold that one
Swing around this one, dance around she
Catch a hold this one, catch a hold that one
Diddle dum this one, diddle dum dee.

Sally is the pride of Cat Harbour
Ain't been swung since late last year
Since she met that fellow from Fortune
Who came down a-fishing last year.

Chorus

Uncle George got up in the morning
He got up in a heck of a tear
Tore the seat right out of his trousers
Now he's got no pair to wear.

Chorus

Lukey's Boat

A Newfoundland folk song
http://teresadoyle.bandcamp.com/track/lukeys-boat

Lukey's boat is painted green, aha, me boys,
Lukey's boat is painted green, the finest boat you've ever seen.
Aha, aha, me riddle I day.

Lukey's boat got high a fine fore cuddy, aha, me boys,
Lukey's boat got a fine fore cuddy, and every seam is chinked with putty.
Aha, aha, me riddle I day.

I think, says Lukey, I'll make her bigger, aha, me boys,
I think, says Lukey, I'll make her bigger, I'll load her down with a one-claw jigger.
Aha, aha, me riddle I day.

Lukey's sailin' down the shore, aha, me boys
Lukey's sailin' down the shore, to catch some fish in Labrador.
Aha, aha, me riddle I day.

Lukey's rolling out his grub, aha, me boys,
Lukey's rolling out his grub, one split pea in a ten pound tub.
Aha, aha, me riddle I day.

Aha, says Lukey, the blinds are down, aha, me boys,
Aha, says Lukey, the blinds are down, me wife is dead and underground.
Aha, aha, me riddle I day.

Aha, says Lukey, I don't care, aha, me boys,
Aha, says Lukey, I don't care, I'll get me another in the spring of the year.
Aha, aha, me riddle I day.

Lukey's boat is painted green, aha, me boys,
Lukey's boat is painted green, the finest boat you've ever seen,
Aha, aha, me riddle I day.

Peter's Dream
© Lennie Gallant
http://www.lenniegallant.com/music.html

I still get up before the day breaks
And I still walk down to the shore
I watch the sun rise from the eastern ocean
But I don't sail to meet anymore

How could they have let this happen
We saw it coming years ago
The greedy ships kept getting bigger and bigger
And the sonar told them where to go

Chorus
Last night I dreamed that I was sailing
Out on the Sea of Galilee
We cast our nets upon the waters
And Jesus pulled them in with me

Where am I gonna go now
What about this boat I own
What about this old piano
What about my father's bones

Chorus

Someone sang an old sea shanty
And Nealy told a mainland joke
Kelly cursed and swore until his voice gave out
And then he asked me for a smoke

Chorus

And then he took his father's shotgun
Walked to the harbour, through the town
He fired fourteen times, woke everyone up
And we all watched that boat go down

Chorus

Sweet Molly Mavis
© Wendy Jones

When sweet Molly Mavis stares out to the sea,
Is she dreaming of Jimmy or thinking of me?
Why Jimmy is gone now she never will learn,
But she knows that our Jimmy will never return.

She doesn't know how our Jimmy was lost,
Fell from that trawler, was in the sea tossed.
She carried his baby did sweet Molly Mavis,
Oh but that girl, how she loved Jimmy Davis.

Now Jimmy grew up in the house next to me,
We played and we partied and we fished in the sea.
Handsome and hearty, most girls from our town,
Knew our young Jimmy would ne'er settle down.

When Sweet Molly Mavis so young and so pure,
Caught Jimmy's eye with her innocent allure,
I couldn't convince him to let Molly be,
That Molly was more suited to courting with me,

Jimmy was charming, Molly loved him true,
She fell for his lies, thought that he loved her too.
Sweet Molly she wanted to walk down the aisle
So Jimmy moved slowly, courted her with guile.

One day my friend Jimmy a few pints was drinkin',
Was way too far-gone then for sensible thinkin'.
When Molly said no well he just wouldn't heed,
Since Molly loved Jimmy she finally agreed.

Now Jimmy had no want for a wife and some babies,
He'd a need for the good life, for fishin' and the ladies.
But I was a man who'd give Molly my all,
I loved Molly Mavis, from the start I did fall.

When we were out in a big blowing gale,
My best friend Jimmy he told me a tale,
Of another he wanted, she was not Molly Mavis,
He was cruel and cold-hearted was our Jimmy Davis.

He laughed as he hollered o'er the wind and the sea,
"I'm leaving Molly Mavis, no good husband will I be!"
I dragged on the lines saw the seas come up high,
I took my chance, saw that Jimmy must die.

Sweet Molly Mavis had eyes only for him,
As long as he lived, my chances were dim.
I shoved Jimmy Davis and o'er he did fall,
When he was a goner, I gave out the call.

"Our Jimmy's gone over!" I hollered to the crew,
And with great gusto the buoy I threw,
The captain and the men tried with all of their might
To rescue our Jimmy through the long stormy night.

Hard as they tried though, their trouble was in vain,
My best friend Jimmy in his coffin was lain,
I knew I must linger, my time I must bide.
Sweet Molly Mavis she cried and she cried.

When sweet Molly Mavis stares out to the sea,
Is she dreaming of Jimmy or thinking of me?
Why Jimmy is gone now she never will learn,
But she knows that our Jimmy will never return.

She'll never know how her Jimmy was lost,
Fell from that trawler, was in the sea tossed.
I never told her that Jimmy planned to leave,
So for ages and ages she sat to grieve.

When she had Jimmy's baby oh how she did weep,
That bonny wee baby his memory did keep.
I stayed by my Molly to comfort and care,
But my deepest feelings I still couldn't share.

One cold autumn eve when the seas crashed and tossed
I couldn't wait any longer, had to ask at any cost.
Even though Molly Mavis for Jimmy still pined,
I asked my sweet Molly, "Would she be mine?"

Molly's been my wife now for many a good year
And still I have to wonder, still I have to fear.
When she sits by the window and stares out to sea
Is she dreaming of Jimmy or thinking of me.

When she sits by the window and stares out to sea
Is she dreaming of Jimmy or thinking of me....

Tales of the Phantom Ship
© Lennie Gallant 2014
http://www.lenniegallant.com/music.html

On a night as black as a raven's feather
Thunder cracks like a snap of leather
And the wind whips through the black spruce on the shore
Waves are pounding the beaches harder
As the last of the fishermen reach safe harbour
And the wind turns cold, cuts to the core.

Out on the wide Northumberland Strait
A ball of fire skips over the waves
And those who watch now can't believe their eyes
There's a burst of flame and a flash of light
And there on the tide is a frightening sight
As a tall ship all aflame lights up the sky.

Chorus
Tales of the Phantom Ship, from truck to keel in flames
She sails the wide Northumberland Strait
No one knows her name
Tales of the Phantom Ship. It's a ship of fire they cry
Hard against the wind she sails
No one can say why.

They say she's a three masted square-rigger
Four hundred tons or maybe bigger
With fire on every rope and spar and sail
Out of the east though the wind blows west
She ploughs the strait on an unknown quest
Cutting through the waves with the strength of a full force gale.

Of why she appears there's none who know
Some say it's nothing but a moonlight glow
But those who've seen her swear they tell no lies
They tell how her bow suddenly drops down
And into the depths of the strait she's bound
As the wind goes wild with wailing chilling cries.

Chorus

Some say she's an immigrant ship of old
Highland Scots whose land was stolen
Lost at sea while seeking the new land
Or a ghostly American privateer
Who plundered innocent harbours here
Cursed to sail the strait, forever damned.

But an old man sang a song to me –
Six hundred Acadians drowned at sea
Deported long ago from St. John's Isle
He says they sail this choppy strait
Through time and tide they navigate
Searching for the means to end their long exile.

Chorus

The Sailor's Alphabet
A traditional Maritime folksong
http://teresadoyle.bandcamp.com/track/sailors-alphabet

'A' for the anchor of our gallant ship,
And "B" for the bowsprit, so neatly does fit,
'C' for the capstan, we all go around,
And 'D' for the davits our boat hands upon.

Chorus
So merry, so merry, so merry are we,
No mortals on earth are like sailors at sea.
To me hi, to me ho, to me hi diddle dum,
Give sailors their grub, and there's nothing wrong.

'E' for the ensign so gallant and true,
'F' for the fo'stle that holds all our crew,
'G' for the grub that our captain sends 'round,
'H' for the halyards we all sway upon.

Chorus

'I' for the iron on our topsail boom
'J' for the jigger block on the yardarm,
'K' for the keel way down below,
'L' for the lanyards we heave to and fro.

Chorus

'M' for Merlin spike that hangs on the nail,
'N' for the needle to sew up our sails,
'O' for the oars of our jolly boat,
'P' for the pump that keeps us afloat.

Chorus
'Q' for the quarterdeck polished and strong,
'R' for the rudder that steers her along,
'S' for the sails that drive her ahead,
'T' for the taffrail when we threw out the lead.

Chorus
'U' for the ugliest cloud of them all,
'V' for the vapour that comes from the squall
'W' for the windlass on which we do wind,
'XYZ' well I can't do the rhyme.

The Stormy Weather Boys
Traditional Maritime folksong
http://teresadoyle.bandcamp.com/track/stormy-weather-boys

Chorus
And it's windy weather, boys, stormy weather, boys,
When the wind blows, we're all together, boys;
Blow ye winds westerly, blow ye winds, blow,
Jolly sou'wester, boys, steady she goes.

Up jumps the eel with his slippery tail,
Climbs up aloft and reefs the topsail;
Up jumps the shark with his nine rows of teeth,
Saying, "You eat the dough boys, and I'll eat the beef!"

Chorus

Up jumps the mackerel with his striped back,
Saying, "Watch your eyes captain, it's time for to tack"
Up jumps the lobster with his heavy claws,
Bites the main boom right off by the jaws!

Chorus

Up jumps the halibut, lies flat on the deck,
He says, "Mister Captain, don't step on my neck!"
Up jumps the herring, the king of the sea,
Saying, "All other fishes, now you follow me!"

Chorus

Up jumps the codfish with his chuckle-head,
He runs out up forward and throws out the lead!
Up jumps the whale... the largest of all,
He heaves on the windlass pawl after pawl.

Chorus

The Yankee Gale
©Pete Blanding

When I was just a lad of twelve I shipped away to sea
And the constant strain of the wind and waves made a sailor out of me.
I was just a 'ship's boy', and still wet behind the ears
And the tales I heard in the months to come only justified my fears.
Many a day when the sun beat down and life on board got dull
A tale was told about the days of old and the ghost ship, the Chronicle.
The Chronicle was a schooner, boys, and close to ninety tons
She was lost in the Yankee Gale in 1851.

They had sailed up from the Boston States with a crew of nine and three
They came through the Canso Strait bound for the Bay of Tracadie.
Her crew were all Americans, and prideful men, they say
And they fished the schools of mackerel in the warm St. Lawrence Bay.
Her captain was a Yankee, too, but no religious man was he
Why, if he'd been more superstitious he'd have never put to sea.

It was calm that 3 October, so the old Islanders tell
But the sea was brewing something up that could only come from Hell.
Some say that God was angry at these Americans, full of pride
Or because they fished on Friday… (that's the day that Jesus died)
But sailors are God-fearing men, though lusty they might be
And many a sailor crossed himself that day when they put to sea.

Either way it was unlucky, in that time of ships and sail
For God drew his breath in anger and blew in the Yankee Gale!
Oh, the wind hit like a mighty fist, and Chronicle ran for shore
They thought they had the harbor made, but then the mainsail tore.
Some swear that lightning struck the mast, and flames lit up the night
That the Devil danced a jig on deck - and the sailors died of fright!

Well, the rumor spread, then the news was read that the Chronicle went down
And though they searched for many a day, never a trace was found.
But the Islanders swear she's out there still; they've seen her, all a-flame
She's all that's left from the Yankee Gale - and Chronicle is her name.

So, if ever you're lost at sea, my boy - you've only just to call
And you'll join your mates at the Pearly Gates on the ghost ship, the Chronicle.
For there's a melody off the open sea whenever a ship goes down.
And then blowing in on the stormy wind you'll hear this mournful sound,
(they're singing)
Blow ye winds, blow - we'll ride the windy sea.
Oh, Davy Jones is my First Mate, and it's Fiddler's Green for me!

Chapter Four

Songs of the Land

Abegweit
© Lennie Gallant (2013)
http://www.lenniegallant.com/music.html

From the legend of great Glooscap
From the 'people of the dawn'
This name was given to you
So tender and so strong
Born of storm and fury
From an ocean cold and deep
Came an island where the Great Spirit
Would lay his head to sleep

Chorus
Abegweit, 'cradled on the waves'
Gently rock me home tonight
And I'll forever stay
Abegweit, sing to me your song
When I hear your lullaby
I know where I belong

Over dunes that line the shoreline
Through the black spruce on the cliffs
Down in the furrowed fields of red
Your melody will drift
Then rise up on the eagle's wings
And dive into the sea
To the rhythm of survival
And the life you gave to me

In the strathspey at the ceilidh
The Acadian complainte
All the heartache of the journey
Safe arrival in the dance
All the birdsong in the morning
As the boats head out to sea
I can hear the elders calling out
The name you are to me

Chorus

Instrumental bridge

Chorus

From the legend of great Glooscap
From the 'people of the dawn'
This name was given to you
Now you know where you belong....
Abegweit...Abegweit...Abegweit

Canoe Round

A Traditional Canadian folksong
http://teresadoyle.bandcamp.com/track/canoe-round

My paddle's keen and bright
Flashing with silver
Follow the wild goose flight
Dip, dip and swing

Dip, dip and swing her back
Flashing with silver
Follow the wild goose track
Dip, dip and swing

Country Life
Traditional English
http://teresadoyle.bandcamp.com/track/the-country-life

Chorus
Oh I like to rise when the sun she rises early in the morning
I like to hear the small birds singing merrily upon their lay-land
And hurrah for the life of a country girl
And to ramble in the new mown hay.

In the spring we sow, in the harvest mow
And that's how the seasons around they go
But of all the times if choose I may
It's to ramble in the new mown hay.

Chorus

In the winter when the sky is grey
We edge & ditch our life away
But in summer when the sun shines gay
We go rambling in the new mown hay.

Chorus

Island Working Man

© Barry O'Brien
barryobrienmusic.bandcamp.com

Through my bedroom window I can hear the working sounds
Of the torches burning metal and the beams that hit the ground
The pays alright and the job is good at least it keeps you honest
It's just one small step to help put your kids through college

Chorus
You work all week for money you hardly see,
They never sleep and they are away from their families
They may not like it but they do the best they can.
It's a song of an island working man

Through my bedroom window I can hear the engines' roar
Of the boats that leave the harbour you know fishing starts at four
It's hard to make a living in an industry gone rotten,
They still lay their traps off the Isle of Boughten

Chorus

Through my bedroom window I can see their lives unfold,
Suddenly I realize their stories must be told
From labour strikes and lost lives forgotten in the fold
Seasons change, they still remain, they are this island's soul.

Chorus x 2

Jimmy's Jig
Teresa Doyle 2012
http://teresadoyle.bandcamp.com/track/jimmys-jig

I like to get up in the morning
See the cows out on the hay
Watch the sun rise in the meadow
Welcome the gifts of the day.

I like to walk out in the evening
The kids and the dog at my heels
Check on the cows in the meadow
Look over the crops in the fields.

At the end of the day I take pleasure
In all of the chores I have done
A fine piece of land is a treasure
I'm glad to call this one my own.

Mud Beautiful Mud
© Rollie MacKinnon

It's that time of the year, the spring's comin' soon
The boys want to court the girls 'neath the moon
The flowers in blossom, the trees are in bud
If there was only a way to get through this red mud!

Chorus
Mud, beautiful mud
Mud, beautiful mud
On the highways the potholes will give you a thud
On the byways you're up to your axles in mud!

Old Mary Crosby lived on Riley's Lane
It's hard packed in summer, except when it rains
Or early in spring when the snow melt is done
To tell you the truth boys, it's nothin' but mud!

Chorus

Early one spring, our story unfolds
Mary decided to go for a stroll
She stepped from her doorway, no one heard the thud
Bejaysus! She's up to her axle in mud!
And it's...

Chorus

Her friends they assembled to do what they could
Some made suggestions, others just stood
Some tried explosive, it proved out a dud
Poor Mary's still up to her axle in mud
And it's...

Chorus

Several days later the parish priest came
To pay her a visit, he called out her name
She cried "Father dear, don't stop to chew cud
I've been seven days with me axle in mud!"
And it's...

Chorus

Now the city department arrived on the scene
With backhoe and shovel and other machines
Two trucks, six buses, a foreman called "Bud"
Still Mary's old axle held fast in the mud.

Chorus

But finally the day came, they freed her at last
There were fifty two horses, and thirty jackass
Six tractors, two graders, and barrels of gas
To get her old axle back up on the grass!
And it's...

Chorus

Ode to Elsetkook
© Tony Reddin

Paddles flashing in the sun, gliding up along the banks
With the forest cool and quiet reaching inland on each side
The Mi'kmaq people came this way to busy summer camps
For game and fish aplenty Elsetkook did provide.

Chorus
And you've seen them come and go through the ages
Come and go with the ebb and flow of tide
From the Bay up to the Head, all along your watershed
Fair Hillsborough, the river of our lives.

Puis de France les immigrants arrivent, des fermiers extraordinaires
Pour habiter en Acadie avec une vision de paix
A Port La Joye ils construisent protection mais la guerre les suit
Ceux qui ne se cachent pas son banis de leur foyer.

(Instrumental- the Elsetkook Reel)

Then so to clear the fertile land more immigrants arrive
The Celtic Cross at Scotchfort bears a witness to their hands
And when the tenants got their titles clear well then came prosperous times
With villages of merchants making trade of every kind:

Webster's Corner, Little York, St. Andrews, Bedford, Tracadie Cross, Mount Stewart
Marshfield, Mermaid, Pisquid, Southport, Suffolk, Fort Augustus
Johnston's River, Cherry Hill, Glenroy, Glenfinnan, Ten Mile House, Dunstaffnage
Frenchfort, Scotchfort, Head of Hillsborough and Bunbury.

Chorus

So generations have worked and played along your banks and on your waters
Building bridges, moving churches, fencing pastures in a row
Now so many cross your span each day, not realizing how you've changed
But you take it all in season, may you never...Ohhh please don't overflow.

Chorus

Old MacDonald

© Margie Carmichael SOCAN 1995
Recorded: Carmichael Sisters – Under the Lindens 1995

Old MacDonald had a farm, a mortgage and a withered arm
That only made him try harder
And by his side would Mary be, with strong back and a rosary
That held her when he could not be there
"It's a lovely farm my dear, in the laughter and the tears
Is the heartbeat that makes sense out of it all."

She took a job in a restaurant
And it took the edge off need and want
But they missed their sunrises in the morning.
And when the sun set on their lives
Softened hands drew paper knives
Their debtors gave up and gave warning
"It's still our farm my dear," she whispered through her tears
And their courage made believers of us all.

Chorus
Old MacDonald had a farm E-I-E-I-O
And on this farm he had a dream E-I-E-I-O

They lost the farm in '82
There was nothing more that they could do
They were beaten, broken, distant
They packed it up on a winter's day
Their rusted dreams on frozen clay
She closed her eyes, he couldn't turn away.

Chorus

Part of him died that day
The rest of him just fades away
He hasn't said a word to her since spring
And the sorrow in our mother's eyes
Speaks of a hallowed place inside
The mate for whom the bird no longer sings.
Chorus
E-I-E-O (repeat 3-4 times, fade)

Prince Edward Isle, Adieu
Lawrence Doyle, 1880's

Come all ye hardy sons of toil
Pray lend an ear to me
Whilst I relate the dismal state
Of this our country
I will not pause to name the cause
But keep it close in view;
For comrades grieve when they must leave
And bid this Isle adieu.

There is a band within this land
Who live in pomp and pride;
To swell their stores they rob the poor;
On pleasures' wings they ride.
With dishes fine their tables shine,
They live in princely style.
Those are the knaves who made us slaves,
And sold Prince Edward Isle.

Through want and care and scanty fare,
The poor man drags along;
He hears a whistle loud and shrill,
The "Iron Horse" speeds on;
He throws his pack upon his back,
There's nothing left to do;
He boards the train for Bangor, Maine,
Prince Edward Isle adieu.

The reason why so many fly,
And leave their Island home;
Because 'tis clear, they can't stay here,
For work to do there's none;
In other climes there's better times,
There can't be worse 'tis true;
So weal or woe, away they go,
Prince Edward Isle adieu.

But changes great have come of late,
And brought some curious things;
Dominion men have brought us in,
With our own railway rings;
There's maps and charts, and towns apart,
And tramps of every style;
There's doctors mute and lawyers cute,
Upon Prince Edward Isle.

There's judges too, who find a clue
To all the merchants' bills;
There's school trustees, who want no fees
For using all their skill;
There's laws for dogs, for geese, for hogs,
At this pray do not smile,
For changes great have come of late,
Upon Prince Edward Isle.

So here's success to all who press
The question of Free Trade;
Join hand in hand, our cause is grand;
They're plainly in the shade.
The mainland route, the world throughout,
Take courage now, stand true,
My verse is run, my song is done,
Prince Edward Isle adieu.

Red Dirt Road
© Margie Carmichael May/1993

Oh the red dirt road wasn't easy traveling
Especially early in the spring
Mud to the belly made many turn back -
Forget about planning anything
People got their horses out and graded it themselves
They didn't need a road machine
They didn't need politicians to improve the conditions
And the grass grew green

Chorus
On the red dirt road
The red dirt road
On the red dirt road

Riding to the Celidhs, dropping in on the neighbors
Church on Sunday too
Never made strangers of the people next door
Like these times tend to do
The doctor came by when anyone was sick,
Half the time he never got a cent
Yeah the red dirt road made neighbors of us all
And we were all content

Then the auto was invented, the horses were tormented
And everybody started giving in
Soon a lot of them were driving fancy little rigs
And they were sporting their expensive little grins
They widened all the ruts; they raised a lot of dust
That settled on the wagon and the sleigh
When the red dirt road wasn't coping with the load
They paved it away

I grew up on a red dirt road
My feet got tough on a red dirt road
I fell in love on a red dirt road

The red dirt road ... mud oozes through your toes
The red dirt road ... take your sweetie for a stroll
The red dirt road ... say hello to uncle Joe

The red dirt road ... clip clopping
The red dirt road ... hip-hopping of the hare
The red dirt road ... I'm wishing I was there

The red dirt road ... drip-dropping of the rain
The red dirt road ... flip-flopping of the mane
The red dirt road ... I'm coming home again

The red dirt road ...slap-slapping in the heat
The red dirt road ... swat-swatting in the heat
The red dirt road ... hey, mosquitoes gotta eat

The Mist Covered Mountains of Home

Traditional Scottish
https://teresadoyle.bandcamp.com/album/dance-to-your-daddy

Chorus
Home, home, soon shall I see them Oh!
Hey ho see them Oh! See them Oh!
Ho ro soon shall I see them
The mist covered mountains of home.

Soon I shall visit the place of my birth
And they'll give me a welcome the warmest on earth
So loving and kind full of music and mirth
In the sweet sounding language of home.

Chorus

There I shall gaze on the mountains again
The sweet smelling woods, the hills and the glens
And the way among people beyond human ken
In the haunt of the deer I shall roam

Chorus

Hail to the mountains their summits so blue
The hills and the valleys with sunshine and dew
To the women and men and the friends that I knew
And the way that they welcome one home.

The Shearing
Traditional Scottish
http://teresadoyle.bandcamp.com/album/if-fish-could-sing-and-sheep-could-dance

Chorus
Bonny laddie will ye nay gang
Shear with me the whole day long
And love will cheer us as we gang
To join yon band of shearers.

Summer days and heather bells
Are ringing in the silent hills
There's yellow corn in yonder fields
And autumn brings the shearing.

Chorus

And if the weather it be dry
They'll say there's love 'tween you and I
They'll say there's love 'tween you and I
When autumn brings the shearing.

Chorus

And when the harvest it be done
We'll have some ranting roaring fun
We'll have some ranting roaring fun
When autumn brings the shearing.

Chorus

The Shoes of the Fisherman
© Pete Blanding
http://www.cdbaby.com/cd/peteblanding

My father once told me, when I was a young man
'Think hard what you'll be, son, when you are grown
I've had a good life, out on the ocean
With many a catch and many a memory
To carry me home.

Those were the good times, with my father beside me
We sailed early mornings; we hauled up the sun
I fished with my father; I remember his laughter
And the tales that he told are my silver and gold
Long after he's gone.

Those were the good times, with my father beside me
We sailed early mornings; we hauled up the sun
I fished with my father; I remember his laughter
And the tales that he told are my silver and gold
Long after he's gone.

Chorus

Put your boat in the water and quiet your soul
Push off from the shoreline, and let yourself go
Like your brothers before you, trust your heart to the sea
The shoes of the fisherman were made for thee.

Now the times they're a-changing; now there's work in the cities
Not many a young man will a fisherman be
But don't be afraid, son, to follow the old ways
To learn all you can about nature and man, go down to the sea

Chorus

Chapter Five

Songs of African Canadians
The Old Stock

Blackjack Byers
© Scott Parsons
http://www.cdbaby.com/cd/scottparsons

Lt. Colonel Robinson, a loyalist from the States
Brought to the Island of St John's, a couple who were slaves
Blackjack and Amelia Byers might have their liberty
At the end of one year, if they were well-behaved.

1804 the story goes, Blackjack before the court
Stealing to the value of ten pence, they tied him to a cart
From Harvey's Brig at Pownal Square, they whipped him to the stocks
Thence to the wharf and back to gaol, their hopes of freedom lost.

Soon after this, notorious judicial punishment
Was laid upon two of their sons, they hanged them for their sins
Sancho stole bread and butter, Peter a few coins
A travesty of justice on the Island of St John's.

Dembo Suckles

© Scott Parsons
http://www.cdbaby.com/cd/scottparsons

He was born in Africa,
Slavers raided his native place
Ran and hid in a hollow log,
Dembo Suckles would soon be his name.

Chorus
Dembo hid in a hollow log,
Slavers searched and found him there
He was dragged from his hiding place,
By an iron hook stuck into his back.
He could show to his dying day, the mark left by that cruel hook
He could show to his dying day, the mark left by that cruel hook

The year of 1793, Reverend MacGregor opposed to slavery
Manumission at the standard rate,
Good Captain Creed agreed to free his slave.

Chorus

Given one good cow, two sheep, one sow, and a suit of clothes upon his back
Dembo truly a self-made man, bought a hundred acres of land
Married Governor Fanning's slave,
Lived life to a very great age.

Chorus

Is Sook Willin'
© Scott Parsons
http://www.cdbaby.com/cd/scottparsons

I know a secret that's very old
I know a secret if the truth be told
I know a secret though some will say
Save your secrets for the judgment day.

Chorus
Well, is Sook willin'? (Answer) Is Sook willin'?
Well, is Sook willin'? (Answer) Is Sook willin'?
Well, is Sook willin'? (Answer) Is Sook willin'?
Is Sook willin' to marry you?

Now love is a mighty and wonderful thing
Doesn't care what religion or songs you sing
Doesn't care 'bout the color of your skin
Doesn't care if it's a sin

Chorus

Hope for better things to come
Hope and the day is won
Hope as love shines through
To a better day for me and you.

Chorus

Jupiter Wise
© Scott Parsons
http://www.cdbaby.com/cd/scottparsons

Court records from 1785
Case of the King versus Jupiter Wise
Convicted of assault, he was sentenced to die.
The King versus Jupiter Wise
The King versus Jupiter Wise.

Called him a thief and a violent slave, he never guessed what his friends would say
Meant to steal a boat for the United States and be a free man for the rest of his days
Jupiter, Jupiter Wise, for assaulting John Clark they're gonna hang you high
Plead Benefit of Clergy and save your life.
The King versus Jupiter Wise
The King versus Jupiter Wise.

Sent for seven years service to his Majesty's Isles
The case of the King Versus Jupiter Wise
A slave in the west Indies last we heard of his life.
The King versus Jupiter Wise,
The King versus Jupiter Wise.

Klondike Gold

© Scott Parsons
http://www.cdbaby.com/cd/scottparsons

Lemuel and Robert of the Sheppard family, left Cardigan 'round 1896
They worked in Maine for years,
To earn enough money
To go in search of Klondike gold.

A good many hard knocks, we went hungry more than once
Just kept on diggin' all the day
The nights were hard and black, they could tear a man asunder
Better fellows, we watched as they went under.

Then there it was one day after years of arduous toil
We finally struck the pay streak
We headed back to Maine, gold nuggets that we gave
To loved ones who helped us on our way.

Home to Prince Edward Isle, with a fortune and a smile
We helped the whole community
We believe in church and farm, and spinning Klondike yarn
With our good friends and family.

One Spanish Dollar
© Scott Parsons
http://www.cdbaby.com/cd/scottparsons

One Spanish dollar and an English half crown
One stole bread and butter, the other five pounds
Some fish for his mother, hanged 'till they be dead
The family was outraged, at the price that they paid.

Black Peter and Sancho both hanged for their crimes
A travesty of justice on Prince Edward Isle
For one Spanish dollar and an English half crown
One stole bread and butter the other five pounds.

In the cold light of morning, in the hours before dawn
Black Peter and Sancho, would soon be beyond
Their poor hearts would tremble in fear all the while
The hangman awaits them on Price Edward's Isle.

For one Spanish dollar and an English half crown
One stole bread and butter, the other five pounds
Black Peter and Sancho, both hanged for their crimes
A travesty of justice, on Prince Edward's Isle.

The Old Stock
© Scott Parsons
http://www.cdbaby.com/cd/scottparsons

Hmmmnn Hmmnn, It's been a long time, it's been a long, long time….

(Spoken)
The Old Stock are still here, just can't be seen
For a long time, perhaps it was better that way.

I recall, my father said to me, folks round here have plain forgot
They're a part of the old stock, the old stock with ancient Africa in their veins.

The old stock, he'd laugh and say, things aren't always what they seem
He'd point out many people in the community.

Now times have changed and there's no shame in common history
The old stock lives on and on inside of you and me.

You got a hard name; you got a hard name my son
Byer's a hard name, a hard name my son
Byer's a hard name, part of the old stock.

The Sheppard Accident
© Scott Parsons
http://www.cdbaby.com/cd/scottparsons

Sheppard and his son, cutting fence rails in the woods
Sent home with a full load, the boy did not return
Sheppard searched and found, tipped over on the ground
The horse had fallen a short distance from the house

Returning to the scene, Sheppard shocked by what he saw
The dead boys feet stuck out from underneath the horse
Sheppard crawled on hands and knees, threatened friends and family
Taken to the Georgetown jail by the law

A lunatic they said, caused by the accident
The unfortunate man was brought to town
To the asylum he was sent, by the local government
To live out, the rest of his life

The bereavement of the family, a shocking calamity. February, 1869

What I Am
© Scott Parsons
http://www.cdbaby.com/cd/scottparsons

Everybody wants to know what I am, what I am, what I am
Everybody wants to know what I am, what I am

I am an Englishman, I am an African,
I am an Indian, I am a human

Some folks don't understand there's already enough pain.
Some folks don't understand inside we're all the same.
Some folks don't understand there's better things to do.
Some folks don't understand no matter what you do.

Everybody want to know
Everybody want to know.

(Repeat all)

Chapter Six

Songs of Mirth and Magic

A Carrion Crow

A traditional English Folk Song
http://teresadoyle.bandcamp.com/track/carrion-crow

A carrion crow sat on an oak
To me inkum kiddy kum kimo
Watching a tailor mend his coat
To me inkum kiddy kum kimo

Chorus
Key me near oh, kitty come kero
Key me near oh, ki mo
Bop, bop, bop, bop, billie illy inkum
Inkum kitty cum ki mo.

Bring me an arrow and a bow
To me inkum kiddy kum ki mo
Till I go shoot that carrion crow
To me inkum kiddy kum ki mo.

Chorus

The old man fired, he missed his mark
To me inkum kiddy kum ki mo
He shot that old sow through the heart
To me inkum kiddy kum ki mo

Chorus

Bring me molasses in a spoon
To me inkum kiddy kum ki mo
Till I go heal that old sow's wound
To me inkum kiddy kum ki mo

Chorus

Now the old sow's dead and gone
To me inkum kiddy kum ki mo
Her little ones go waddlin' on
To me inkum kiddy kum ki mo

Chorus

A Leg Of Mutton
Traditional Newfoundland folksong
http://teresadoyle.bandcamp.com/track/a-leg-of-mutton

A leg of mutton went over to France
Right fal diddle aye day
A leg of mutton went over to France
The ladies did sing and the gentlemen dance
To me right fal diddle aye day

There was a man and he was dead
Right fal diddle aye day
There was a man and he was dead
They sent for the doctor to look in his head
To me right fal diddle aye day

In his head there was a pool
Right fal diddle aye day
In his head there was a pool
Where all the young salmon they went to school
To me right fal diddle aye day

In the school there was a spring
Right fal diddle aye day
In the school there was a spring
Where 39 salmon were learning to sing
To me right fal diddle aye day

One of them was as big as I
Right fal diddle aye day
One of them was as big as I
I hope you don't think that I'm singing a lie
To me right fal diddle aye day

One of them was as small as an elf
Right fal diddle aye day
One of them was as small as an elf
If you want anymore you can sing it yourself.
To me right fal diddle aye day

Colcannon

Traditional Irish
http://teresadoyle.bandcamp.com/track/colcannon

Did you ever make potato cakes with lovely pickled cream
The greens & scallions mingled like a picture in a dream?
Did you ever make a hole on top to hold the meltin' flake
Of the creamy flavoured soft and meltin' sweet potato cake?

Chorus
Oh you did, so you did so did she, and so did I
And the more I think about it sure the nearer I could cry
Weren't them the happy days when troubles we knew not
And our mother made colcannon in the little skillet pot.

Did you ever take potato cakes and boxty to the school
Tucked underneath your oxter with your books, your slate and rule?
When teacher wasn't lookin' sure a great big bite you'd take
Of the creamy flavoured soft and meltin' sweet potato cake.

Chorus

Did you ever go a courtin' boys when the evenin' sun went down
The moon was shining brightly from behind the willow down?
Did you wander down the boreen where the clúrachán was seen,
Whisperin' love and praises to your own dear sweet Colleen?

Chorus

False Knight on the Road
Traditional Scottish
http://teresadoyle.bandcamp.com/track/false-knight-on-the-road

"Oh, where are you going?" said the false knight on the road.
"I'm going to me school," says the wee boy and still he stood.
"What is on your back?" said the false knight on the road.
"Me bundles and me books," said the wee boy and still he stood.

"I wish you were in yonder tree," said the false knight on the road.
"And a good ladder under me," said the wee boy and still he stood.
"The ladder it will break," said the false knight on the road.
"Then you will surely fall," said the wee boy and still he stood.

"What is whiter than the milk?" said the false knight on the road.
"Snow is whiter than the milk," said the wee boy and still he stood.
"What is softer than the silk?" said the false knight on the road.
"Down is softer than the silk," said the wee boy and still he stood.

"I wish you were in yonder sea," said the false knight on the road.
"And a good boat under me," said the wee boy and still he stood.
"The boat will surely sink," said the false knight on the road.
"Then you will surely drown," said the wee boy and still he stood.

"Is your mother calling you?" said the false knight on the road.
"Oh, I think it is for you," said the wee boy and still he stood.
"I think I hear a bell," said the false knight on the road.
"It's not for me to tell," said the wee boy and still he stood.

Girl on the Dunes

© Teresa Doyle
http://teresadoyle.bandcamp.com/album/song-road

Cold river flowing, soft breezes blowing
Blackbirds fill the skies
Boats in the harbour, fishermen gather
The tide is on the rise
Out on the beachhead, a young girl's camped out
Sailors flock to her door
Send us fine weather, find us good shelter
See our boats safely to shore.

Chorus
Like a dove in the distant sky
Out upon the dunes she cries.
Oh that sweet young girl
Cast upon a cruel world.

Lonely she wanders, silently ponders
The tragedy wrought by this place.
Who will protect her, offer her shelter?
Wipe the tears from her face
And when she goes walking, the town folks are talking
They say she has secrets untold
Perhaps some strange powers, with herbs and with flowers
It's best they just leave her alone.

Chorus

Cold river flowing, soft breezes blowing
Blackbirds fill the skies
Boats in the harbour, fishermen gather
The tide is on the rise.
The tide is on the rise.
The tide is on the rise.

Home by Barna

Traditional Irish. Verses three and four by Teresa Doyle
http://teresadoyle.bandcamp.com/track/home-by-barna

In Scarlateglen there lived a lass
And every morning after mass
She would go and take a glass
Before going home by Barna

We won't go home along the road
For fear that we might tax the rogue
We won't go home along the road
We'll go home by Barna

We won't go home across the fields
The big thorn needles will stick in our heels
We won't go home across the fields
We'll go home by Barna

We won't go home the milk boreen
The night is bright we might be seen
We won't go home the milk boreen
We'll go home by Barna

We won't go home along the bay
The tinkers' camp is on the way
We won't go home along the bay
We'll go home by Barna

We won't go home along the main
The swoogh is sure to rise again
We won't go home along the main
We'll go home by Barna

We won't go home along the shore
For fear we hear the banshee roar
We won't go home along the shore
We'll go home by Barna

We won't go home along the strand
We might disturb the fairy band
We won't go home along the strand
We'll go home by Barna

Milk boreen: cow path; Tinkers: travelers; Swoogh - departed souls that transport people.
Banshee - a fairy woman who wails near the home of someone soon to depart this life.

Maggie Lachlin's Last Storm
© Teresa Doyle 2010
http://teresadoyle.bandcamp.com/track/maggie-lachlins-last-storm

Maggie Lachlin Gillis loved her pipe.
She'd smoke it on the back porch of her place above the harbour
Drinking black tea and molasses from the Co-op in Bear River.

Long widowed and forgotten and alone.
When lobster season came she'd wander back down to the harbour
Trading stories at the cookhouse, reading tea leaves for young lovers.

Maggie Lachlin Gillis had the sight.
Like her Grandaddy before her she had the gift to read the water
She could feel a storm a-comin,' give all the sailors warning.

Chorus
She heard the birds cry, and the seas crash
And the winds roar, and the waves lash
And the cold seas, and the high tide
And the fierce wind from the cruel eye of the storm.

Maggie's Granddad foresaw the Yankee Gale
A thousand sailors perished, but not a man in Clear Springs Harbour
Put an oar into the water, after Lachlin gave the warning.

Chorus

Harvest moon 1923
Boats on blocks for winter, Maggie Lachlin had a vision
Saw all the boats in Clear Springs piled up at the bridge a good mile inland.

And folks said, "Maggie Lachlin's lost her mind."
But when the gale roared up the Clear Springs Brook
It pushed every boat, and line and hook
Piled them a mile from the shore, at the bridge, way up at the highway.

Chorus x 2

Not An Islander
© Margie Carmichael April/2001

My name is Hector Jelley, and this is my complaint.
My twin brother is an Islander, but holy smokes I ain't!
I was born aboard The Abegweit and I came as quite a shock -
But some idiot cut my umbilical cord before the ferry docked.

My younger brother Borden, he loves to rub it in
That he's the native Islander and I the 'distant twin'
I was always Tonto, he was always The Lone Ranger
He got all the cuddly names, they just called me 'stranger'.

Chorus
So is it by default? Or is it by injection?
Is it come by honestly? Or is it an infection?
Won't someone tell me please before they put me in the earth
How in the name of God do I become an Islander?

I loved a girl from Carleton and she said she'd be my wife
A third-generation Islander, I'd known her all my life
She called it off the night before and she phoned me up to say
"I could never tell a child of mine that his daddy's from away!"

In my long and lonely later years my prospects looked so cruddy
That I dug deep down for the truth in the Institute of Island Studies
The experts said that when I'm dead I may lie in the family plot
But even genetically qualified, an Islander I'm not.

Chorus

At ninety-five I finally died and I went to the Pearly Gates
Surely to God by now I thought I'd found my rightful place
But Saint Peter said "Oh Hector! I'd love to let you stay
And Heaven's full of Islanders, but you're still from away."

The Devil saw me coming and he licked his lips with glee
As he thought about the torture to inflict eternally.
Then God yelled down from Heaven "Do be gentle Lucifer!
Hector's been through Hell already trying to be an Islander."

Chorus

So is it by default? Or is it by injection?
Is it come by honestly? Or is it an infection?
Won't someone tell me please before they put me in the earth
How in the name of God do I become an Islander?
Won't someone tell me please before they burn me with the worst
How in the name of God do I be re-incarnated or modified?
How in the name of God do I become an Islander?

The Shan Vhan Voght
By the great satirical Island writer Larry Gorman.

Oh I'm getting very gaunt, said the Shan Van Vocht
Of provisions I am scant, said the Shan Van Vocht
When Forbes he does come here, it's the very place we'll steer
We'll get everything we want, said the Shan Van Vocht

We will promise him a sleigh, said the Shan Van Vocht
And a half a ton of hay, said the Shan Van Vocht
We'll promise him some wheat, some barley and some meat
Just before we run away, said the Shan Van Vocht.

Oh I've just some into deal, said the Shan Van Vocht
Have you any Indian meal, said the Shan Van Vocht
I mean to pay you soon by the latter part of June
With a carcass of fresh veal, said the Shan Van Vocht.

Oh I want a pair of boots, said the Shan VanVocht
If the payment only suits, said the Shan Van Vocht
A pair both high and strong, I'll pay you before long,
My husbands digging roots, said the Shan Van Vocht.

Oh I want some yellow dye said the Shan Van Vocht
And some concentrated lye said the Shan Van Vocht
I have no money now but I give my solemn vow
I'll pay you by and by, said the Shan Van Vocht.

Oh I want a new tea tray, said the Shan Van Vocht
If you trust me for to pay, said the Shan Van Vocht
If I'm only on my legs I'll bring you down some eggs
When the hens begin to lay, said the Shan Van Vocht.

Then I'd like some woolly tweed, said the Shan Van Vocht
And I'd like some clover seed, said the Shan Van Vocht
I want a lamp and flue and I'd like a box of blue
And that's all I really need, said the Shan Van Vocht.

Oh I'd like a water jug, said the Shan Van Vocht
And a brand new chamber mug, said the Shan Van Vocht
I've been troubled this last year, with one with just one ear
And it's very hard to lug, said the Shan Van Vocht.

Now just tell me what is due, said the Shan Van Vocht
And I hope you will not sue, said the Shan Van Vocht
Then tot up my account and give me the amount
And that's all I ask of you, said the Shan Van Vocht.

Shan Van Vocht means poor old woman. Gorman observed a wily old neighbour walking into a new store in the district and imagined the bartering she was promising to the unsuspecting storekeeper.

When I'm Gone
© Meaghan Blanchard

When I'm gone
Set a beehive on my grave
So the sweetness of that honey
Will be with me every day
Though it never be as sweet darling
As the kisses that you gave
When I'm gone
Set a beehive on my grave

When I'm gone
Lay me down beneath the trees
On a bed of honeysuckles
For the birds and for the bees
Though it never be as softly
As you holding on to me
When I'm gone
Lay me down beneath the trees

Instrumental interlude

When I'm gone
There'll be nothing left to say
For the clouds my heart has carried
Will all wash away
Oh and I will wait in the silence
'Til we meet again some day
When I'm gone
There'll be nothing left to say
When I'm gone
Set a beehive on my grave

When I'm gone
Set a beehive on my grave

www.ingramcontent.com/pod-product-compliance
Lightning Source LLC
Chambersburg PA
CBHW080229180526
45158CB00008BA/2269